A Memoir of

Samuel Palmer

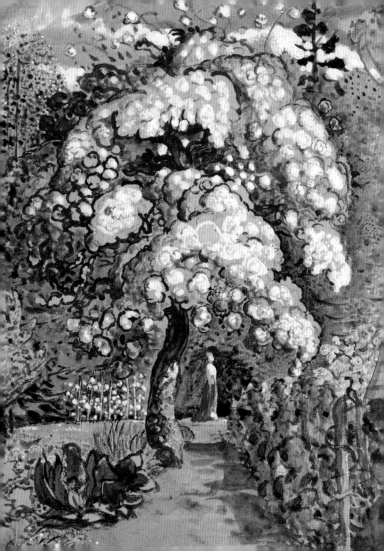

A Memoir of **Samuel Palmer**

Samuel Palmer

A. H. Palmer

F. G. Stephens

introduced by
William Vaughan

J. Paul Getty Museum, Los Angeles

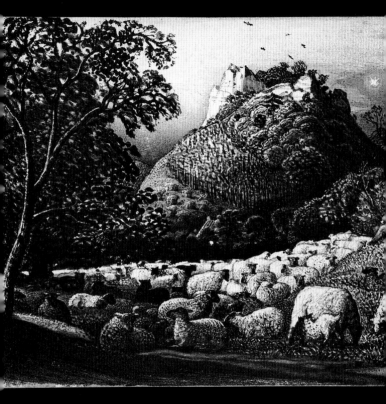

The Flock and the Star
c. 1831-32

CONTENTS

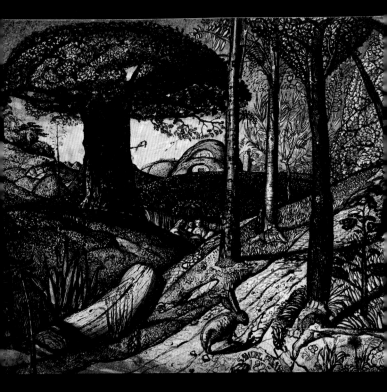

Early Morning, 1825

'I rose anone and thought I would be gone
Into the wode, to heare the birds sing,
When that misty vapour was agone
And cleare and faire was the morning.'
(John Lydgate)

INTRODUCTION

WILLIAM VAUGHAN

Samuel Palmer is one of the most original and intriguing of British artists, a leading landscapist of the Romantic era. This book republishes the earliest important texts on his life and art. These include his own autobiographical letter of 1871 and the essay by the critic F. G. Stephens that accompanied the first major retrospective of Palmer's work, held at the Fine Art Society just after his death in 1881. As well as providing a fine assessment of Palmer's overall achievement, Stephens' essay is valuable for providing the first detailed account of works from the artist's early 'Shoreham' period, the time when he produced such innovative masterpieces as *The Magic Apple Tree* (Fitzwilliam Museum, Cambridge, ill. p. 36), *In a Shoreham Garden* (Victoria & Albert Museum, London, ill. p. 2) and *The Bright Cloud* (Manchester City Art Gallery, ill. pp. 58-59) and its sister painting, *The White Cloud* (Ashmolean Museum, ill. overleaf), for which he is most celebrated today.

Born in 1805, Palmer came to maturity at a time when landscape painting was at its height in Britain.

The White Cloud,
c. 1833-34

Turner was the acknowledged master, demonstrating an ability to represent the various moods of nature with unprecedented virtuosity and boldness. Constable was depicting local English scenery with unrivalled directness and freshness. It is hardly surprising that the young Palmer should be encouraged by such achievements to explore the natural world in his own art. Yet while he began as a precocious naturalistic painter — already exhibiting in the Royal Academy at the age of fourteen — he soon developed his own and highly different approach.

It has long been recognized that landscape painting in the early nineteenth century, while offering images of relaxation and visual pleasure, could also constitute a political and social critique. Like the verse of contemporaneous poets such as Wordsworth and Coleridge, it set the splendour of nature — in their eyes the work of God — against the corruptness and materialism of the man-made city. In an age of growing industrialization and alienation, the contrasted virtues of the natural world took on an increasing allure.

This sense of critique is ever present in Palmer's finest work. Born in South London — in Surrey Square, off the Old Kent Road — he looked to the country with all the yearning of a city dweller. His family encouraged such attitudes. His father was a

dreamy bookseller and fervent Baptist lay preacher. Palmer was reared in a world of literature and religion, and at first wanted to become a clergyman. He turned to art in his early teens, after having suffered the loss of his mother and a traumatic brief period at school. Trained privately, he started exhibiting and selling pictures at a very early age. These first works are competent, but hardly original — a sketch for one is illustrated on p. 30 — and Palmer himself soon felt dissatisfied with their limitations.

In 1820 Palmer's father moved his bookshop and family to Broad Street in Bloomsbury, near the British Museum. This area was one of the main centres of artistic activity in London at the time, and contacts Palmer made there widened his horizons dramatically. The first important acquaintance was with a somewhat older fellow landscape painter, John Linnell. Though a sharp-eyed naturalist himself, Linnell appreciated the visionary and he venerated Blake, to whom he introduced Palmer in 1824. The meeting was to transform Palmer's life and art. As well as thrilling to Blake's own work, Palmer also followed Blake in admiring the firm draughtsmanship and expressive forms of artists of the fifteenth and early sixteenth centuries — notably Michelangelo and Dürer. Palmer became fascinated in particular by the

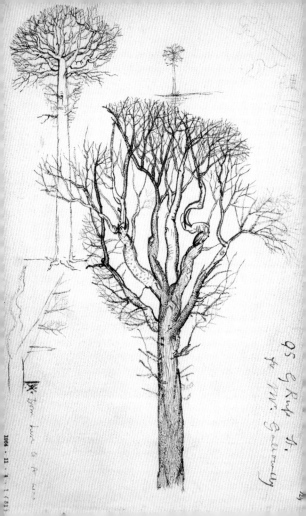

vigorous visual language of prints of that time and set out to emulate these in his own work.

Nothing shows this change more fully than the extraordinary sketchbook of 1824 (British Museum and Victoria & Albert Museum). Palmer's manner could hardly be more different from the earlier work. Whereas in that he explored atmosphere and tonalities, here he stresses lines and textures. In one drawing (ill. opposite) he turns the crown of a tree into a unique pattern of fascinating complexity, at once individual and infinite. Sadly much work from this exciting period has been lost. However there is a set of six sepias at the Ashmolean Museum, Oxford, dated 1825, that show how Palmer used his new vision in finished works. All show local, intimate forms of scenery transformed by a fresh perception. In one, a tender spring day is enlivened by the exhilarating appearance of a bright cloud looming through the trees. In another (ill. p. 6) Palmer takes some lines from a poem then thought to be by Chaucer to describe the clarity of the early morning, where he imagines a small hare taking an unhurried, peaceful stroll through the woods.

At about this time Palmer drew together a group of

Opposite: Tree Studies, from the sketchbook of 1824

like-minded young artists. Calling themselves 'The Ancients', they turned their backs on the modern world and sought for what they called the 'revival of art' by going back to the middle ages. They were one of the earliest of the breakaway artistic groups that have become such a pattern in modern art; and in particular they were in many ways precursors of the Pre-Raphaelite Brotherhood.

Palmer also sought to withdraw from modernity physically by retiring to the Kent village of Shoreham. He probably first visited Shoreham in 1824, but he lived there more or less permanently from 1827 to 1835, accompanied some of the time by other members of the Ancients. This was where Palmer was able to realize his vision most fully. Nowadays we wonder at the boldness of this work — so original for an artist working at this time — that apparently prefigures so much that was to take place in art in the later nineteenth and even the twentieth centuries. But we have to remember that most of what we admire so much in Palmer was painted effectively for himself. Fortunately he had a legacy from his grandfather and this meant that he could paint for a time without need of commission. Not that there was anything amateurish

Opposite: Pastoral with a Horse-Chestnut Tree, c. 1831-32

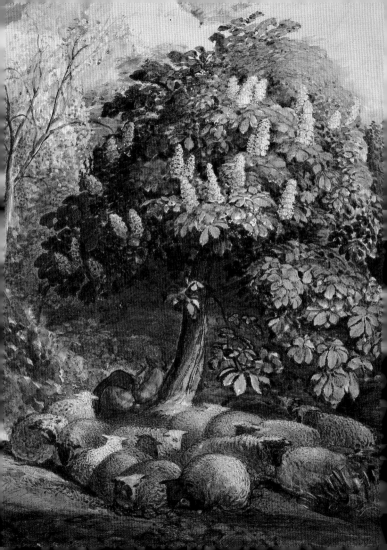

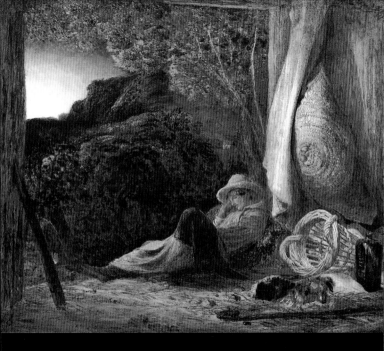

The Sleeping Shepherd,
c. 1834-35

about his art. He was completely serious in his profession and regularly sent his works for exhibition. Towards the end of his time at Shoreham — when funds were running out — he strove to produce works that he hoped would have a broader appeal, combining his wonder at the mysteriousness of nature with a carefully controlled and highly accomplished manner of painting. The result was some of his finest creations, such as the *Sleeping Shepherd* (private collection, ill. opposite), with its mesmerising moonlight. But he had no more luck selling these than he did his most experimental work.

Palmer left Shoreham in 1835, returning to London. He began to travel — first to the West and Wales and then in 1837 to Italy. His painting, while remaining high in quality, became more conventional. It was a time, as he put it later, when 'real life began'. He married and had children. Times were hard, but gradually professional recognition came. In time he developed a beautiful, melancholic, yet lyrical style as a watercolourist. He also became respected as an etcher, a printing method he began to practice around 1850.

In 1861 Palmer experienced the trauma of his life. This was the death of his favourite son, Thomas More, after a long and painful illness. He became reclusive, retiring to live at Redhill in Surrey. Yet this

new retreat also brought a return to vision. This can be seen best, perhaps, in a cycle of illustrations that he did to work by Milton, first in watercolours, and then as etchings. One of these, *The Lonely Tower*, is widely regarded as his late masterpiece. It comes from Milton's *Il Penseroso* and depicts the 'lonely tower' in which the poem's narrator spends his nights studying the stars. There is a haunting mood to this finely wrought print that later caused the poet W. B. Yeats to speak of Palmer's 'mysterious wisdom won by toil'.

Palmer was reassessed in the early twentieth century when his experimental Shoreham works became a talisman for artists like Graham Sutherland and John Piper, who were seeking to forge an art that was both modern and expressive of a British visionary tradition. Before that time, Palmer's reputation rested largely on his later watercolours and etchings. Such a valuation is evident in the early accounts of his work that constitute the texts in this collection. These begin with Palmer's own brief autobiography — sent by the artist to the critic F. G. Stephens and published in 1872 in *The Portfolio*. There follow the essays published in the catalogue of the retrospective of Palmer's work held at the Fine Art Society in 1881, including the first, brief, account of Palmer by his principal biographer — his younger son, Alfred Herbert — and a perceptive

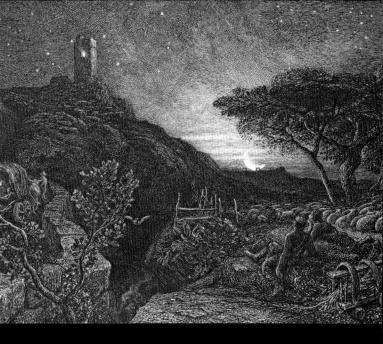

The Lonely Tower,
c. 1879

appreciation by F. G. Stephens, who seems also to have edited A. H. Palmer's contribution.

Palmer's short autobiography is a moving document that gives a vivid image of the resigned mood of his later years. It is striking how much the narrative sketched out here has formed the basis of all later accounts. Palmer stresses his supportive and protective home and the love of literature and religion imbued in him. He includes the anecdote, retold by all other biographers, of his experience as a young child of the sight of the shadow of a tree against a wall, made memorable to him by some lines on human transience recited by his nurse, Mary Ward. The autobiography also stresses the central importance of his meeting with Blake, and the seminal importance of his years in Shoreham — the happiest time in his life. His later career he touches on in the briefest manner, introduced by the laconic sentence 'Real life began'. The only details he dwells on this 'real life' are the tragic deaths of two of his children, the last being the occasion for meditation on his own approaching end.

The exhibition of Palmer's work at the Fine Art Society in 1881 was the artist's first retrospective. It would seem from a note at the front of this catalogue that Palmer had himself been planning this exhibition prior to his death in May that year. Quite possibly the

biographical information provided by Palmer's son was sketched out under the parental eye. Alfred Herbert lived very much in the shadow of his father at that time. He had learned etching to help his father finish the plates for his edition of Virgil's *Eclogues* and appears to have been a general assistant. The tone of his biographical account is appropriately dutiful. It is of interest both as the first outline of later fuller accounts and because it continues the stress laid by Palmer himself on the importance of Blake and Shoreham in his career. The selection of works for the exhibition included five pictures from the Shoreham period. Interestingly, these are all oil paintings. This was the medium that Palmer had first hoped to succeed in, only abandoning it to become a specialist watercolourist after his early works had failed to sell or find any critical success. At the end of his life Palmer seemed keen to remind the public that he had achieved something substantial before winning approval as a watercolourist and etcher in his later years.

It is highly appropriate that F. G. Stephens should have provided an appraisal for the Fine Art Society catalogue. As a critic he had been Palmer's most constant defender in the press. At this time Stephens was the resident art critic of the prestigious periodical *The*

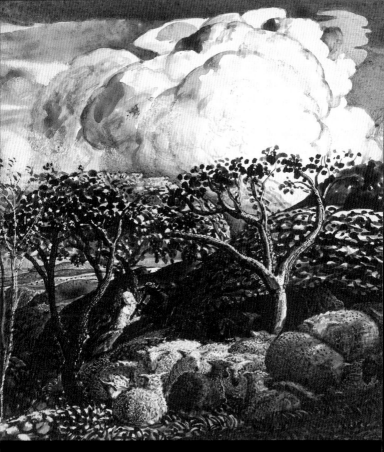

Athenæum — a post he held for over forty years, until replaced by Roger Fry in 1901. A level-headed and perceptive critic with a commitment to bringing art to a wide audience, Stephens gained authority from having been one of the original members of the Pre-Raphaelite Brotherhood. His handsome, somewhat saturnine features can be seen among the figures of a number of early works by Millais, Hunt and Madox Brown. While his reviews of subsequent Pre-Raphaelite works could be somewhat partial — he was given to allowing Rossetti to provide copy about his own pictures in reviews — his assessment of other works was untarnished. He probably first developed a sympathy for Palmer's work when Palmer came into contact with Rossetti on account of their mutual interest in Blake. In subsequent reviews Stephens dubbed Palmer a painter 'in the Dorian mood', using an analogue with one of the severer modes of ancient Greek and ecclesiastical music to characterize the melancholy and learned lyricism of the artist's exhibited watercolours. The essay in the Fine Art Society catalogue addressed the works exhibited to some extent, but was also based — as Stephens made clear — on interviews with the artist himself. It is one of the

Opposite: Preparatory drawing for 'The Bright Cloud', c. 1831-32

greatest merits of Stephens' account that it provides the first critical engagement with Palmer's early Shoreham period, even though his main concern was to assess the later etchings and watercolours. He was acutely aware of the differences between the early and later works, and used a memorable poetic analogy to characterize the difference. Whereas the freshness and vividness of the early work made him think of Keats, the rich melancholy and elaborate technique of the later work put him in mind of Tennyson. It is an analogy that we can agree with, though it might have different implications for us than it did for him. When Stephens wrote, Tennyson was the God of contemporary poetry and every bit a match for Keats. For us the relationship is different. Similarly, while appreciating the undoubted high qualities of the Victorian Palmer, it is the earlier, Keatsian, Palmer — with his vivid and original perception of nature — that holds our attention the most. Despite this shift in balance, F. G. Stephens' essay is still well worth reading as the first perceptive and analytical account of the artist's career, and one that was written as a result of conversations with the artist himself.

SAMUEL PALMER

Autobiographical letter
to F. G. Stephens

1 November 1871

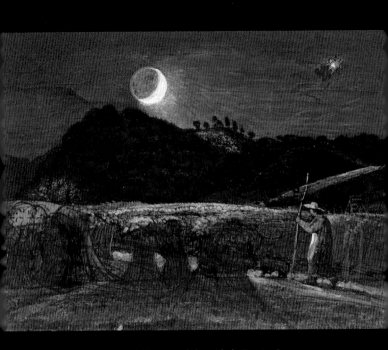

Cornfield by Moonlight, with the Evening Star
c. 1830

Furze Hill
Red Hill
Nov. 1, 1871

My dear Sir

If my life-dream must be told, it begins with good parents, who, thinking me too fragile for school, gave me at home the groundwork of education; sound Latin, so far as it went, with the rudiments of Greek; and my father, having notions of his own, thought that a little English might not be superfluous.

Could my simple story answer any useful purpose, it would do so by warning young students to avoid my mistakes, and in recording, if space allowed, traits of wisdom and goodness in friends with whom I have providentially been connected. In my father, for instance, who, by little and little, made me learn by heart much of the Holy Scriptures. He carried in his waistcoat pocket little manuscript books with vellum covers, transcribing in them the essence of whatever he had lately read, so that, in our many walks together, there was always some topic of interest when the route was weary or unattractive.

I remember, too, the priceless value of a faithful and intelligent domestic, my nurse, who, with little education else, was ripe in that without which so much is often useless or mischievous; deeply read in her Bible and *Paradise Lost*. A Tonson's *Milton*, which I cherish to this day, was her present. When less than four years old, as I was standing with her, watching the shadows on the wall from branches of elm behind which the moon had risen, she transferred and fixed the fleeting image in my memory by repeating the couplet,—

> Vain man, the vision of a moment made,
> Dream of a dream, and shadow of a shade.*

I never forgot those shadows, and am often trying to paint them.

At thirteen, or a little earlier, I lost a most affectionate mother; the original, it was said, of Stothard's 'Lavinia', in one of my grandfather's works. Another, the *Guide to Domestic Happiness*, has its niche among the *British Classics*.

Soon afterwards it was thought right that I should attempt painting as a profession. Perhaps this arose from misinterpreting an instinct of another kind, a

* Young's paraphrase of Job 38, 1, l. 187

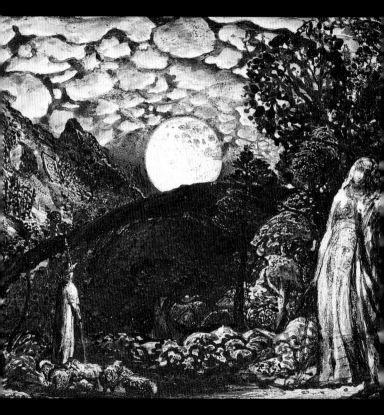

Shepherds under a full moon,
c. 1826-30

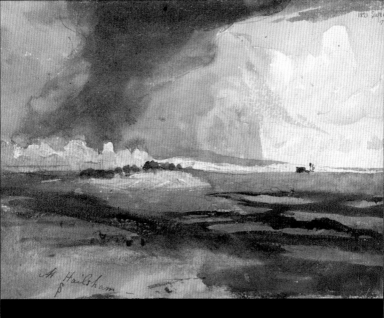

At Hailsham, Sussex: Storm Approaching

passionate love — the expression is not too strong — for the traditions and monuments of the Church; its cloistered abbeys, cathedrals and minsters, which I was always imagining and trying to draw; spoiling much paper with pencils, crayons, and water-colours. It was in the blood: my great-grandfather was a clergyman, and his father, Samuel Palmer, was collated to the living of Wiley in Wiltshire, in 1728.

On my fourteenth birthday, I received a letter from the British Gallery, announcing the sale of my first exhibited picture,[1] and an invitation to visit the purchaser, who desired to give me further encouragement. No doubt it added zest to the plum-pudding; but I was unacquainted with artists, and time was misused until my introduction to Mr. Linnell, who took a very kind interest in my improvement, and advised me at once to begin a course of figure-drawing, which was, in some sort, carried out at the British Museum; but sedulous efforts to render the marbles exactly, even to their granulation, led me too much aside from the study of organisation and structure. 'The painter,' said Mulready, 'cannot take a step without anatomy.' Yet having thus learned to read, if I may so express it,

1. Untraced

the surface, he will investigate its most subtle inflections and textures, for if he have not learned to perceive all that is before him, how can he select? how can he approach the mastery of knowing what should be omitted? Hence Mulready remarked, that no one had done much who had not begun with niggling.

About this time Mr. Linnell introduced me to William Blake. He fixed his grey eyes upon me, and said, 'Do you work with fear and trembling?' 'Yes indeed,' was the reply. 'Then,' said he, 'you'll do.' No lapse of years can efface the memory of hours spent in familiar conversation with that great man. But I must descend.

Forced into the country by illness, I lived afterwards for about seven years at Shoreham, in Kent, with my father, who was inseparable from his books, unless when still better engaged in works of kindness. There, sometimes by ourselves, sometimes visited by friends of congenial taste, literature and art and ancient music whiled away the hours, and a small independence made me heedless, for the time, of further gain; the beautiful was loved for itself, and if it were right, after any sort, to live for our own gratification,

Opposite: Ivy Cottage, Shoreham, c. 1831-32

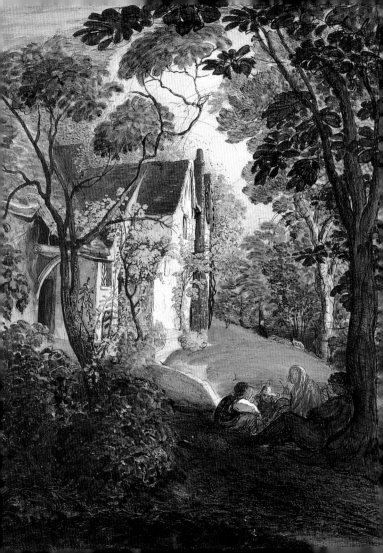

the retrospect might be happy; but two-and-twenty centuries of yore the master of philosophy taught men to distinguish between happiness and pleasure.

In 1839,* I married. The 'wedding trip' was a residence of two years in Italy. Real life began, and soon brought among its troubles the loss of our little daughter. We moved from the scene of affliction to Kensington, where twelve years were spent, and we became acquainted with eminent and excellent neighbours, whose friendship I have the privilege to retain and gratefully acknowledge.

In 1861, after the loss of our elder son, who 'died in harness,' full of noble purpose, we came hither, and from the window at which I am writing, I can see on the slopes of Leith Hill, a woodland ridge, behind which, in Abinger churchyard, the hope and ornament of my life lies alone under his simple monument till it is opened to place me by his side.

I remain, dear Sir, yours very truly,

Samuel Palmer

To F. G. Stephens, Esq.

* In fact 1837

A. H. PALMER

WITH

F. G. STEPHENS

*Life of
Samuel Palmer*

1881

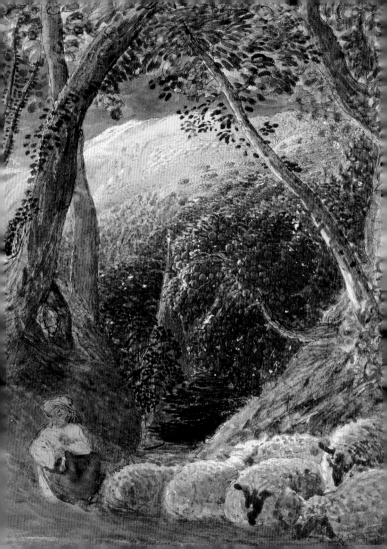

THE artist whose works are gathered before us was born on the 27th of January, 1805, in what was then a very quiet, almost smokeless, and suburban place, Surrey Square, in the Old Kent Road, in the middle of a region which now rings with whistles of railway-engines, and is discordant with a thousand cries. His parents were, as his son has told us in a biography which is soon to be published by The Fine Art Society, 'upright, old-fashioned, and simple-minded people,' who, thinking him too delicate for ordinary school-life, caused him to be grounded at home in knowledge of books, among which the 'classics' of our language were the chief. By means of the painter's record of himself, it is obvious that Milton and the Bible were oftener in his hands than any other volumes. These books bore fruit in every picture, drawing, and etching Palmer gave us: the very spirit of *Il Penseroso* breathes in each of Mr. Valpy's superb cycle of illustrations; the pastoral and idyllic verse of Milton inspired even the less ambitious and less stately works of the artist's earlier life.

Opposite: The Magic Apple Tree, c. 1830. A. H. Palmer, who gave this picture its name, remembered how it 'dwelt apart from some of its Shoreham fellows in "The Curiosity Portfolio"' which was only shown to intimate friends.

When about thirteen years of age his mother died, leaving the boy to the companionship of his father. There can be no doubt that before this time a taste for drawing had manifested itself in the delicate and delicately-nurtured lad who, ere he was fourteen, was, as he said of himself, found exercising his mind, but in a random, unguided manner, in the practice of the rudiments of technical art. Whatever teaching he received, whether that of personal diligence only or from others' hands, it is evident that he had made noteworthy progress when he obtained places for two pictures in the Exhibition of the British Institution of 1819, their titles being *Bridge Scene*, and *Landscape—composition*.[1] He exhibited pictures at the Royal Academy in the same year. It seems as yet uncertain how and at what time Palmer became acquainted with his guide, counsellor, and friend, Mr. Linnell, whose elder daughter he at a much later date married. At any rate the senior painter led his junior in the right path of studies, facilitated his progress in all respects, and introduced him to most of the circle that had gathered about John Varley and his pupil Mulready, two men who, in a sort of joint way, were the teachers of Linnell himself. Not

1. Neither has been traced, though one may relate to the sketch ill. p. 4

less important to Palmer than his instructions by Mr. Linnell was his becoming, by that student's means, one of those whom William Blake, the so-called mystical painter, received into his companionship, and accepted as a humbly-admiring visitor. It was Palmer's wont to speak of the meeting with Blake as one of the greater events of his life.

The first interruption to the course of the studieswhich Linnell counselled and favoured, and to the noble meditations which Blake had prompted, was caused by an attack of illness compelling recourse to country air. A removal to Shoreham, near Sevenoaks, took effect, and resulted in long residence at that still pretty village and the formation of tastes and habits which never ceased to affect the mind of Palmer. What Wharfedale was, as Mr. Ruskin has said, to Turner, Dort to Cuyp, Albano to Claude, what North Wales was to Wilson, Ville d'Avray to Daubigny, and Barbizon to Millet, such, to Samuel Palmer, were Shoreham and Otford-on-the-Darenth. The very sunsettings, gloamings, moonlights, dawnings, days, which survive in the pictures before us, were seen, studied, and recorded there.

A moderate competence enabled the painter and his father to follow, in this rural seclusion, their inclinations for books, and to enjoy that 'learned leisure'

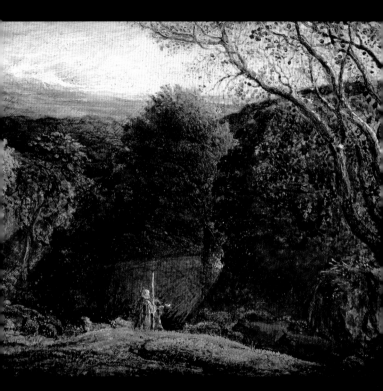

Twilight
c. 1834

which poets have never failed to crave. At Shoreham went onwards those delightful and deliberate studies in design, which are indispensable for the cultivation and ripening of minds like that to which we owe these pictures. At Shoreham were painted such works as *The Bright Cloud*,[1] *The Gleaning Field*,[2] and *Twilight*.[3]

Nearly all Palmer's pictures of this period were in oil. Of these examples, the majority received places in the galleries of the Royal Academy and British Institution. They are perfectly represented in the present gathering by the above-named works and by Mr. J. W. Knights charming idyll of *The Skylark*,[4] which for its own sake, and because it is the forerunner of the famous etching of the same name, is analysed and described in the latter portions of this essay.

The most recent of this category is *The Skylark*, a painting bearing signs of comparatively late labours expended on a landscape not proper to the secluded Kentish village, and, in its motive and inspiration, savouring of a more advanced stage in Palmer's mind and taste than is yet within our purview. At

1. Manchester City Art Gallery, ill. pp. 58-59 2. Tate Britain 3. Richard L. Feigen, New York, ill. opposite 4. Probably the painting now at the National Museum of Wales, Cardiff, ill. p. 62

Shoreham the years flew deliciously, and, we may be sure, but all too fast. Books, especially of the English classics, music, of which Palmer and his father were inappeasably fond; painting, drawing, long walks to London and even farther off, numerous and even lengthy visits from friends, occupied the days or filled the nights with joy. 'Peace, Leisure, and Innocence' prevailed in the little homestead, and brought an honourable happiness to its possessors. For years an English elysium, but surely no 'Sleepy Hollow,' was realised under the Kentish roof-tree.

It is not said whether the bucolic life at Shoreham had, so to say, exhausted itself, or whether a determination grew in Palmer's mind to be in London, 'up and doing,' and amongst the busy ways of men; but it is certain that in 1835 we find the painter settled in a house of his own, No. 4 Grove Street, Lisson Grove, then the heart of a clean, bright, and wholesome region, which is far other than its present condition. There he had on the one hand his friend, E. Calvert, for a neighbour in Park Street, Paddington Green, and on the other hand, at No. 38 Porchester Terrace, Mr. Linnell. In 1836 he went sketching to North Wales.

Another result of coming to London and settling in his own house was matrimony, an event which, a

twelvemonth later, succeeded the Welsh tour. The newly wedded pair made their marriage holiday in Italy, where, during their sojourn of more than two years, both studied diligently and ardently from nature, in cities, gardens, ruins, and fields; not less than from paintings in galleries, churches, and palaces.

Returning to London and its fogs, and, as he supposed, thereby incurring an asthma which plagued him through life, Palmer's next place of settlement was Grove Street, as before. Here he continued to work in oil, but included watercolour painting with that mode of practice. In February 1843 he became an Associate of the Society of Painters in Water Colours. Thenceforth he employed water as the vehicle of his skill. In 1848 he removed to No. 4A Victoria Road, Kensington, to be near Kensington Gardens and the still half-rural Brompton. This year took from him that first and greatest of old friends, his father. Removed once more we find the painter at 6 Douro Place, Victoria Road, and busily at work, producing the staple of his contributions to the gallery of the Society of which he was already a distinguished member. Palmer, like Cox, Mulready, Varley, Linnell, and nearly all the good painters of

Overleaf: The Shearers, c. 1833-34

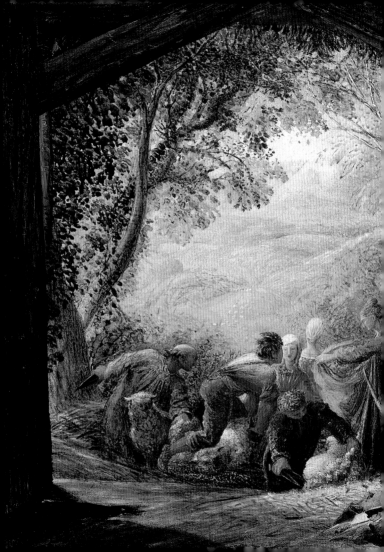

that day and later, was accustomed to give lessons in drawing to pupils at home and abroad, and, doubtless, endured drudgery which must have taxed his energies while it did not add much to his powers. The education of a much-loved and too-early lost son was his chief duty at this period.

In 1853 he was elected a member of the Etching Club. His test or 'probationary' plate was *The Willow*, a very delicate and pretty work; so fine, indeed, that few would take it for a first essay in a difficult mode of draughtsmanship. In 1854 he became a full member of the Society of Painters in Water Colours. He seems to have been at Margate and Red Hill in 1859. In 1861 fell upon the hapless father that most dreadful blow, the weight of which he never failed to recognise as a trial of faith and fortitude. His eldest son, a youth whose promise had encouraged hopes a delicate constitution did not sustain, fell ill, had to be taken from school, and nursed almost hopelessly, in country air. The lad, a victim of overwork, died near Abinger, in Surrey, and was buried in the churchyard of that place. The life-long regret of his father may be said to give deeper sacredness to the grave of this boy.

From Kensington Palmer removed to Reigate, and a year later (1862), he being then fifty-seven

years of age, took his final stand in the house where, in May last, he died. 'Furze Hill, Mead Vale, Reigate,' gives from its ridge on one hand a view of his son's last resting-place at the foot of Leith Hill, on the other hand it opens a long vista of the valley of Kent and Surrey, and in front, enables us to span that high chalk down whose summits overlook the sea. Here he spent the years that were to come; here once again peace, though overshadowed by a long and deep regret, prevailed. Here some of his most splendid, if not his most subtle, pictures, and nearly all those etchings which have spread far and wide his name, were produced. Here reading, music, conversation, and backgammon, or walking, shared with the practice of his art the later days of Samuel Palmer. A one o'clock dinner and a brief preliminary nap favoured afternoon work or enjoyment of home and study till 'blessed green-tea time winds us up,' as he told a friend, 'for Macbeth, or Hamlet, or ecstasy'. One of the more frequent occupations of this period was, as his son relates, the preparation of an English metrical version of the *Eclogues* of Virgil. This task had been begun years before at

Overleaf: Sir Guyon with the Palmer Attending, Tempted by
Phædria to Land upon the Enchanted Islands, 1849

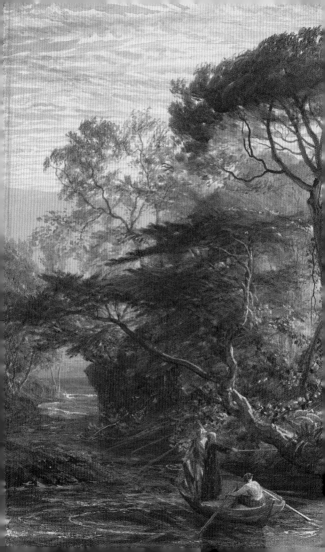

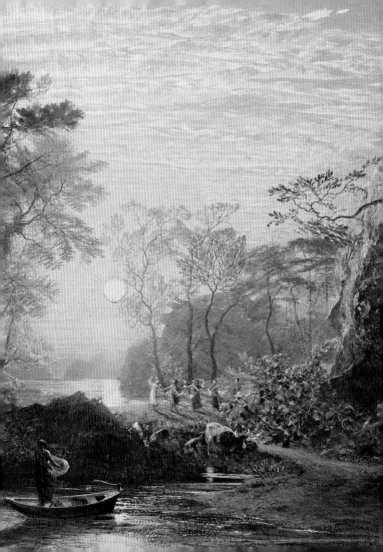

Kensington, but set aside in favour of indispensable painting, teaching, and etching. The matter was resumed at Red Hill, and with ten etchings, the aim of which was to illustrate the idyllic spirit of the poems, the whole was destined for publication. The characteristic fastidiousness of the author, long-delayed labour, which was, as he said, the last to remain of a whole stud of hobbies. Unfinished it exists, the verses, ready, and drawings made or almost completed. It is to be hoped that 'all this patient labour, the cream of half a century of study, will not be wholly thrown away'.[1]

In these occupations and their like, he being diligent, grave, and happy to the last, were passed the later years of the painter. In the words of his son, who not less tenderly than ably described the career and some of the works of Samuel Palmer, it may be said: 'Thus old age crept gently upon him, inexorable, but not unkind. He looked forward with no dread to the approaching change, for he believed it would enable him to enjoy, in a more perfect manner than was possible in this short life, a state of intellectual light and vigour.'

1. The *Eclogues* were eventually published in 1883

F. G. STEPHENS

Notes on some
Pictures, Drawings and Etchings
by Samuel Palmer
exhibited at the Fine Art Society

1881

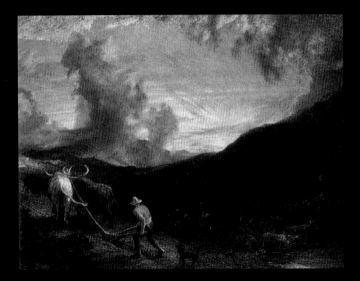

'Right against the eastern gate,
Where the great Sun begins his state,
Rob'd in flames and amber light,
The clouds in thousand liveries dight;
While the ploughman near at hand
Whistles o'er the furrow'd land,
And the milkmaid singeth blithe...'
(John Milton)

THE son of the author of the works which now enrich this Gallery in a manner like to which it has seldom been enriched before, has so piously and well given us the biography of his instructor, that, so far as concerns the man little need be added to his pathetic and earnest testimony, to which we have already alluded. The additional little that is biographical and incorporated with the following descriptions and criticisms was derived from Palmer's own lips and pen, or from those of his friend and teacher, Mr. Linnell, who, though older than himself, survives, and, as Palmer did, informed the present writer. Thus were preserved some details which give thought and life to the biography. By these means it happens that the record is doubly that of the painter, and a hundredfold more precious than if its origin had been of another nature.

Apart from technical matters, artistic training, and the fountain-head of his style — that stately element of Palmer's art — the English painter owed most to William Blake, in diffident companionship with whose congenial spirit he never ceased to take delight.

How deep this sympathetic current of poetical

Opposite: The Eastern Gate, 1881

delight flowed in Palmer's nature will be discovered by those who, looking round this gallery and examining its pictures, begin with that early work in oil called *The Bright Cloud*,[1] in which are figures moving procession-like, after the manner of Blake, and ending with Mr. Valpy's gorgeous spectacular vision, *The Eastern Gate*,[2] where we have the heavens arrayed in splendours of sunrising, and clouds, like gigantic janitors of dawn, suggest the forms of angels on the watch. It has been said by some that in Palmer's colouring they recognise the characteristic chromotography of Blake. I have not been able — I may say, not so unfortunate — to recognise a closer resemblance than is common wherever full tones, grave combinations of rich tints, and vigorous harmonies, occur. But I have frequently, though not always, fancied a much closer likeness between the colouring *per se* of the deceased artist and that of his surviving teacher, Mr. Linnell. That which I may call parallelism seems to exist between the works of these painters in more than one phase of the art of each. Each had his gray period, his olive period, and his golden or ruddy period. I have seen something of the

1. Manchester City Art Gallery, ill. pp. 58-59 2. Private collection, ill. p. 52

like in Mulready's work, here the parallel is imperfect, and in two at least of the stages of the very instructive practice of John Varley. The last-named painter's art is inexcusably neglected, misrepresented, and even misunderstood.

If my observations are not fallacious, they justify saying that the technique of Palmer will never be rightly appreciated by the critic who has not heedfully taken account of what Varley, Mulready, and Linnell gathered and imparted to that classic idyllist on whom, whether he knew it or not, descended the mantle of Adam Elsheimer, which, having been adorned and enlarged, had been worn by Claude and was taken up by Cozens and 'tried on' by Varley, who was the teacher of Mulready, who was the teacher of Linnell, who was — of course, in technical matters only — the instructor of Samuel Palmer, the last known wearer of the mantle. We must not overlook the honour which is due to other classicists, such as Wilson, Cozens, and W. Linton. This is altogether apart from what might be said of Turner whose multiform genius was classic, idyllic, romantic, and realistic by turns, and in each phase the best of all.

In choosing examples for the subjects of these notes, those will be selected which are best fitted for the purpose of illustrating the history of the art of

Palmer, and without much regard to the comparative size, importance, or reputation of the paintings. The examples in oil naturally claim our first attention, because in that material the artist developed his genius to the maturity and perfection which his works in watercolours display. The oil pictures have peculiar interest, because they are practically unknown to this generation of students, who regard Palmer as exclusively a worker in watercolour and as an etcher. The specimens of this class before us represent a much larger number of the works of that artist, who, as his son tells us, generally used oil until he joined the Society of Painters in Water Colours in 1843, when he was thirty-eight years of age. The examples before us of this category possess vigour, richness, brilliance, and force of colour, with depth and what may be called volume of tone, marvellously careful draughtsmanship, and that fine and subtle sense of aërial perspective which gives the greatest charm, and adds much to the profundity of the sentiment of the watercolour drawings before us.

What may be called the pictorial genealogy of Palmer's art has been already suggested and traced through Varley, Mulready, and Linnell. The influence of Mr. Linnell might be traced by comparing works of his silvery, or so-called 'olive' period: for

example, his *Wood Cutters*,[1] with the noble picture here called *The Bright Cloud*, where, with the utmost stateliness of circumstance, a vast white world of cumulus is reared beyond the lofty rounded hill whose forms it repeats. The cloud reflects the warm lustre of the sun, which, slanting from our right, cleaves its way between the trees on that side, ripples against the clumps of fern and gorse of the half-shadowed valley, and then strikes full on the meadows, where it sparkles on the tips of the herbage, projects shadows where the furrows of the plough are not obliterated, and gilds the backs of the cattle which troop onwards to their rest. This is a lovely pastoral scene, and comprises human figures possessing a grace which is intensely expressive, and reminds us of Blake. Their evenly modulated movements attest the care with which Palmer had studied the great old masters he loved. It is right to notice that the artist contented himself with giving the sentiment and the movements of figures of all kinds, and did not exhaust upon them the resources of art, or even care to finish these accessories with searching workmanship. He drew them as well as Claude did,

1. Tate Britain

Overleaf: The Bright Cloud, c. 1833-34

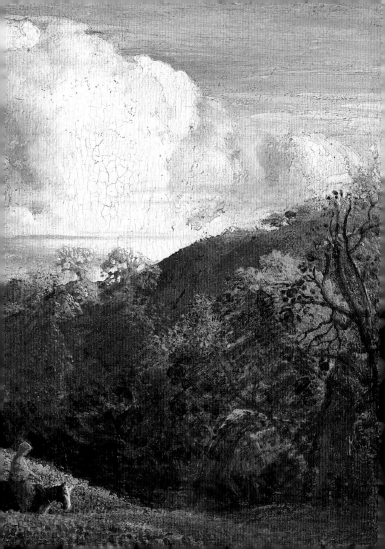

and that seems to have been well enough for Palmer, who regarded men, cattle, and sheep, as accessories, not as chief elements in landscapes. *The Bright Cloud* was originally called *A Rustic Scene*. We see in it a dotted 'vermiculated' touch, which, whether painted or etched, occurs throughout his work. This characteristic is here strongly marked, and shows the artist's hand striving to perfect itself in the mysteries of 'solidity,' long after ability to outline had been obtained, and exquisite felicity of drawing foliage, stones, water, and clouds, had been achieved. Witness the trunks and boughs of the trees before us. How much insight had been gained when Palmer produced *The Bright Cloud* will be perceived by those who study 'the cloud' itself, and peer with us into the mazes of its hollows and its promontories, or examine the vast perspective of its base, which, as an iceberg floats in the sea, floats at its proper level in the air. Ruddy light of the remoter cloudland valleys glows upon the denser part of the avenue of vapours between two enormous piles which, rising on our right, cast clear purple shadows on their lower fellow-pile, whose smaller form ascends on the other side, and is flushed even in the semi-gloom of the shadow. The care of the painter has brought into expressive use the long filmy strata, many which

glow, while others flash in the lustre, and some turn their shadowed sides towards us.

A still simpler motive than that of *The Bright Cloud* inspires the naïf yet lovely pastoral called *A Kentish Hop-Garden*,[1] which is apparently the earliest example of its class on these walls, and wholly reminiscent of the Shoreham region and the serenity of that Arcadia. It shows the highest tide of summer, just before an autumnal turn, when the fully-ripened corn gathers brownness with its gold, when the hop-garden is half stripped, and some of its weather-beaten poles are stacked on one side, when the deep-blue sky is without a cloud, although whiteness gathers on the horizon. For days and days the valley has known no breath of air. In this little picture, which, for depth and richness of tone, and grave, noble harmonies of powerful colour, might be compared with a Titian, is no more than an attempt to render the poetry of nature in the simplest manner. Nevertheless, in it is the majesty of a grave old master's invention; its landscape might have served Tintoret for a 'Flight into Egypt.' The figures Palmer introduced suggest some such an incident; slightly and not searchingly drawn as they are, they have

1. Shizuoka Prefectural Museum of Art, ill. pp. 68-69

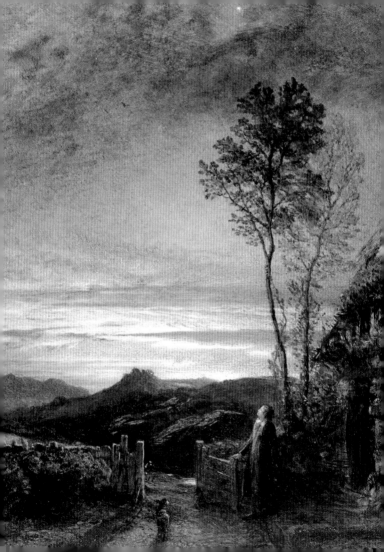

been composed and their movements designed with exemplary care and grace.

A much more developed and thoroughly finished picture, which Mr. J. W. Knight has lent to the Fine Art Society, is apparently the earliest version of the design of the famous etching which, like it, is entitled *The Skylark*.[1] The surface of this gem of painting and charming poem on canvas leads the careful observer to suppose that it was worked upon by Palmer at a date posterior to that of its first execution. The etching and the picture differ considerably in numerous points of detail, but a close likeness obtains between the general appearances of each. Their motives — that is, the inspiration of their designs — are as nearly as possible identical. On comparing one with the other we find the compositions are reversed, the respective figures appear on opposite sides of the designs. In the etching a different and surely less elegant arrangement occurs in the lovely group of trees which is conspicuous there; the cottage has been placed on our left, while in the picture it is on our right, where it is much more prominent than in the other work. The etched figure is smaller than the

1. Probably the painting in the National Museum of Wales, Cardiff

Opposite: The Skylark, c. 1833 and later

painted one; its action has been improved, and even the sentiment it conveys has been elevated. A feathery clump of trees was — with advantage to the aërial perspective as well as to the grading of the masses of tone — added in the middle distance of the plate. In the same work greater abundance of light was admitted to the sky. This change marked a later point of time than the painted one. In the latter night is hardly half-driven from the scene; in the other version, "tis morning, as plain as could be.' The suffusion of sunlight which gives the most exquisite charm to either design is almost confined to the lower part of the painting, and twilight reigns overhead where the morning star has not lost any of its beams. One of the greatest beauties, certainly the crowning subtlety of the art of the painter, is displayed in the tenderness of the flush of dawn, which may be likened to light dust of a nebulous quality, formed, so to say, at the base of the high cumulus that dominates the landscape, and, as it hardly obscures the stars, seems to have bulk without substance. The exquisite tenuity of this vapour, the evenness of the diffusion of light in its prodigious bulk, and the way in which its existence is demonstrated without an outline or a defined boundary, are marvels of execution, and in art-craftsmanship triumph with an ineffable charm.

The Skylark, 1850

Myriads of careful touches, deliberately delicate and fine, were employed to lay, one over the other, those finely graded tints by which the lustre in the vapours has been represented. Light, searching through and through the cloud, has found nothing solid enough to reflect it, and therefore penetrates the body and is lost. The prodigious expanse of the atmosphere is thus represented in a way which is worthy of Turner himself. Nothing can be finer than the luminosity of this semi-diaphanous and vaporous veil of the sky, where the morning star is still supreme. In the spindling trees of the foreground whose sparse foliage has become golden in the first touch of autumn; in the soaring lark, whose 'voice is heard' while his wings are yet darkling though his breast is gilded; in the gray and ruddy vapours behind and above the bird, and in the bluer depths of the firmament, are what may be called stages of aërial distances, each duly graduated and diversely remote from its neighbour. The painted figure, although indispensable for conveying the sentiment of the design, is less happy than many of Palmer's figures are.

Among the oil pictures remaining to be commended to the students who desire to appreciate the work of Samuel Palmer's early and middle life, none deserve more attention than that which is called

Twilight.[1] *The Gleaning Field*[2] is truly delightful. In *Going Home at Curfew Time*,[3] I notice the motive of a late and ambitious drawing.

It has suggested itself to those who are accustomed to compare poems with pictures and poets with painters, that, with regard to Samuel Palmer, the change in his practice from oil painting to water-colour drawing was significant of more than a technical modification of this nature might primarily be supposed to indicate. As this change happened at a critical period of the artist's life, it may account for part of that difference which many have observed in the motives and even the expressiveness of the respective classes of his works. Broadly speaking it may be said that while the oil pictures suggest the poetry of Keats, most of the water-colour drawings ally themselves faithfully to that of Tennyson. As to the third and latest phase of Palmer's labours, we trace in Mr. Valpy's unparalleled group of drawings, the texts of which were borrowed from *Il Penseroso*, something that is Miltonic in those elements which are apart from and beyond the inspiration of the

1. Richard L. Feigen, New York; ill. p. 40 2. Tate Britain, London
3. Victoria & Albert Museum, London

Overleaf: A Kentish Hop-Garden, c. 1833

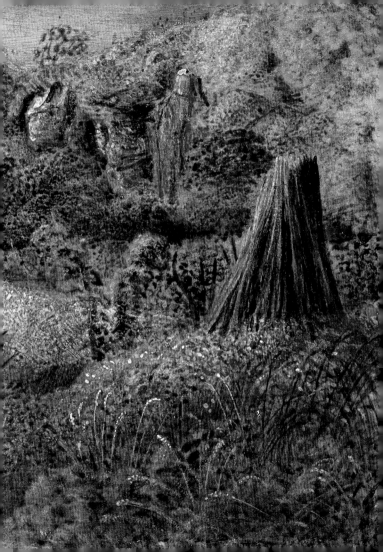

texts. In fact, here are — as in *The Lonely Tower*[1] — not only the Miltonic forms and subjects in art, but Miltonic modes of design and execution. In this category of pictures majestic shadows occur with tones and tints of the gravest and the sweetest order, and matched in rhythmical compositions of stupendous and lovely materials. All these things express, in Palmer's way, the inspiration of Milton, which is not, as with Fuseli, and not seldom even with Blake, a travesty or paraphrase of Milton.

We have seen how Keats-like is the inspiration of *A Kentish Hop-garden*, of *The Skylark*, and of *The Bright Cloud*. We shall find Tennyson-like motives in *The Waters Murmuring*;[2] *The Abbey*,[3] *A Brother come Home from Sea*;[4] *The Early Ploughman*;[5] *The Opening of the Fold*[6] and other watercolour drawings.

Of the purest realism, which is still noble while it is nothing less than faithful, *A Farm-Yard near Prince's Risborough*,[7] the date of which is 1846, contains a fine example in the mossed gray thatch and tiles of the barn, which is the principal, and only finished part,

1. Yale Center for British Art, New Haven 2. ING Bank, London branch, ill. pp. 92-93 3. Untraced 1. Private collection; earlier version in Whitworth Art Gallery, Manchester 2. Untraced 3. Untraced 4. Victoria & Albert Museum, London, ill. pp. 72-73

of the work. The whole is noteworthy, because of the exceptional coolness of the light, which is silvery, but not cold. Its design illustrates some pastoral occupations, including that of the children who drive the sheep homewards while the shadows lengthen, and the thresher who strenuously labours to improve the last daylit hour. Vapours, as yet hardly perceptible, teem in their delicacy between us and the deepening grayness of the chalk down which closes the view and shuts out the horizon. Fading sunlight and spreading shadows still divide the scene. Contrasting with the last in this respect, *The Guardian of the Shores*[1] is almost spectacular, and in its inspiration by no means an example of Palmer's finest taste; yet it is wonderfully 'romantic' and expressive. On the seashore is reared a fortress, whose hollow and dismantled towers rise, skeleton-like, against the brassy sky. These towers no longer hold the beacon which of yore guided the voyager across the sea. A beacon now shines from an humbler pharos on the edge of the waves, and the last little fishing-boats, not tall ships as of old, sail outwards to their nightly toil. On the sheltered cliff-road, where a broken bridge

1. Untraced

Overleaf: A Farm-Yard near Prince's Risborough, 1846

encumbers the stream its arches once bestrode, the herdsmen and shepherds lazily watch their charges troop onwards across bars of light and shadow. Fantastic piles of cloud load the horizon; their darkness, and that of the 'evening band,' as well as the brassy pallor of the sunset, are reflected by the sea, which beats the sand of the deserted nook which was once a haven for whole navies. Red and orange have faded out of the remnant of the daylight, leaving a pallid gold which is sinking into grey twilight.

The dignity of Palmer's Italian studies, the extent and date of which we have already noticed, is apparent in the drawing named *Ancient Rome*,[1] because it represents the white-crowned hills of Albano shining beyond the Forum and its wreckage, and over the mists of the Campagna. An effort has been not unsuccessfully made to depict the ineffable glories of light and colour at sunset as they are shed on the shattered columns of what was once the very centre of the world. The invincible lustre falls on the now ruined triumphal arches of the mistress of innumerable nations; near to those remains is the great dome of St. Peter's, an emblem of the second phase of Rome's dominion. Here nature has been treated in

1. Birmingham City Museums and Art Gallery

an heroic and impressive manner, which is quite different from that prevailing in the earlier, and purely English pictures, some of which have been named above. The manner is equally removed in all respects from that which marks the culmination of Palmer's efforts, and distinguishes the crowning period of his art. This period began with such works as *The Abbey*,[1] the date of which is 1860, and terminated when *The Lonely Tower*,[2] and *The Prospect*,[3] were taken in hand; that is, some years before 1880, when they were finished.

The Italian journey supplied the materials for, if it did not furnish the inspiring motive of, such pictures as *A Golden City*,[4] the epoch of which is 1873. 'It gives us such a vision as floated before the eyes of Columbus and Pizarro ere they went westwards on the sea.' Here the flush of sunset covers and glorifies Rome, its tower of St. Angelo, churches, campaniles, and domes, and, being 'at once a brightness and a shade,' wraps the blue Tiber in a golden veil, and half conceals the ill-kept road that is bordered by fragments of shattered architecture. The neighbouring

1. Untraced 2. Yale Center for British Art, New Haven 3. Ashmolean Museum, Oxford 4. National Gallery of Victoria, Melbourne

Overleaf: A Golden City, 1873

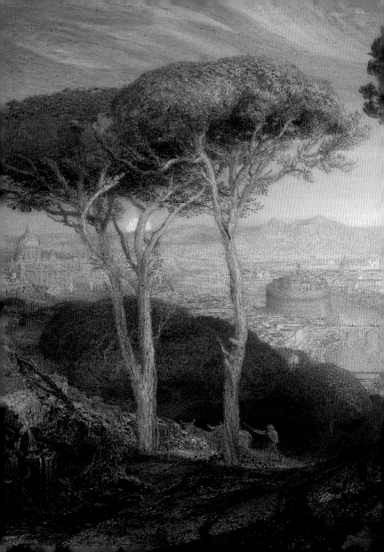

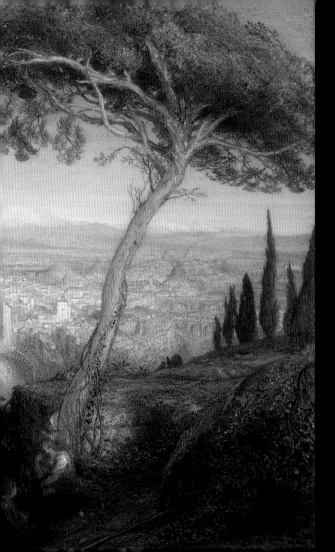

pine-stems lean athwart the tombs, and mingle their dark foliage with the gloomier cypresses. Shadows of twilight creep over all, though the tree-tops still gleam. There was the making of a subject after Turner's heart in this splendid pictorial admonition of the Vanity of Vanities.

In 1847 was begun *A Landscape—Sunset*,[1] a work which, although never finished, retains promise of a noble exercise of skill and invention. It is one of the earliest examples of a practice that was much affected by Palmer in later life, according to which he placed the central light of his design in the rear of, and partly obscured by, a mass of trees, rocks, ruins, or what not, and thence projected large shadows into the middle of his foregrounds. For examples, see the attractive romance in colours, which is called *Sabrina*;[2] *Cattle in the Shallows*;[3] *Sunset over the Sea*;[4] *A Tower'd City*,[5] one of the Valpy series, dated 1868; *The Lonely Tower*;[6] *Tityrus restored to his Patrimony*[7] (1877); *The Eastern Gate*;[8] *The Waters Murmuring*;[9] and *Lowering Clouds*.[10]

1. Untraced 2. Untraced 3. Untraced 4. Ashmolean Museum, Oxford 5. Birmingham City Museums and Art Gallery 6. Yale Center for British Art, New Haven; also Huntington Art Gallery, San Marino, ill. pp. 88-89 7. Birmingham City Museums and Art Gallery 8. Private collection 9. ING Bank, London branch, ill. pp. 92-93 10. Untraced

Below *A Golden City* hangs *A Farm-Yard*,[1] which has been but recently finished, and exists as one of the most valuable exercises of art in the Gallery. It gives us something that is Linnell's combined with more of Gaspar Poussin's than Palmer usually affected. It is a capital exercise in the artistic distribution and rhythmical arrangement of colours and lights and shadows, and as such must have cost the artist abundance of study. *Robinson Crusoe guiding his Raft into the Creek*[2] deserves the careful attention of the visitor, and owes much of its charm to Italian reminiscences. The sun sets, full orbed, partly obscured by clouds, which its radiance seems to fill with fire. The very edges of the clouds below the luminary seem to palpitate, because the intensity of their splendour makes the spectator's eyes quiver. Exquisite orange bars are drawn across the sky, while filmy veils of cirrus blush to the deepest crimson in another place, and lake, gold, purple, and vermilion cross each other and float between us and the firmament, which is here of turquoise blue and there of the deeper azure. The painting of the face of the dwarf cliff behind the creek is one of the most precious of Palmer's efforts. Its blue, gray, and whitish reflections from the sky, are splendidly given.

1. Untraced 2. City Museum, Stoke-on-Trent

A peculiar mode of representing the full-orbed sun, by means of rays of golden light issuing from the luminary, and thus depicting the result of prolonged sun-gazing on the retina, rather than the actual aspect of the luminary itself, is observable in this picture and in others, such as *Tityrus restored to his Patrimony*, where the sun sets behind a lofty coast, and bars of cloud are ablaze, and all the 'pride, pomp, and circumstance' of the day's decline have been represented in their majesty.

Of all the skies which Palmer painted, not one deserves more admiration than that of *The Comet of 1858*.[1] It gives us a peculiar illumination, such as no man painted before, combined with the deepest twilight on a rocky coast, where slow surges fall in a little bay, where the stony tableland of the cliffs, and the trees upon it, the clouds above and the rivulet below, take strange light from the comet, which, plume-like, describes an imperfect arc from the horizon to the zenith in which the stars are, as was noticed at the time, extraordinarily brilliant. The sky is rich in light, colour, and tone, its clouds are triumphs of solidity, and exquisitely modelled.

The Abbey[2] (1860) is a representative drawing of

1. Private collection, ill. pp. 82-83 2. Untraced

high value among the works of Samuel Palmer. Its sad pathos, the contrast of splendid day declining, and the wreck of the architecture of a form of religion that had lost its supremacy, are the inspiring elements of a design not less impressive than beautiful. A romantic charm pervades *A Brother come Home from Sea*[1] (1863), which is instinct with memories of the before-named *Robinson Crusoe* subject, and an idyll which would have charmed Mantegna, Botticelli, or any of the choice painters of the true Italian Renaissance.

These notes may fitly close with memoranda about that category of drawings illustrating Milton's *Il Penseroso* and *L'Allegro*, on which Palmer expended most of the energies of his later years, all the skill a long life had enabled him to develop, and the ripest efforts of his genius. These drawings are uniform in size, they hang in a line on the north side of the room, and all belong to Mr. L. R. Valpy, whose liberality has enriched this Gallery with some of Palmer's masterpieces. The limits of this essay will not admit descriptions of the whole of this group. Examples must be chosen to represent the characteristic qualities of Palmer's inspiration and artistic practice at the

1. Private collection

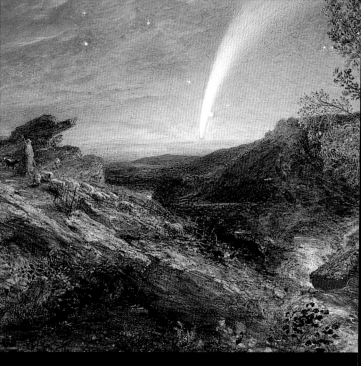

The Comet of 1858, 1858-59

period to which they are referred. *The Curfew*[1] (1870) gives a noble landscape, where the moon, like Wordsworth's 'little boat', is riding high in the serene heavens, and over that 'wide-water'd shore' which Milton imagined. The hour is some time after the sun has gone out of the sky, leaving a blush on the once resplendent 'evening band' — a blush which grows dusky while it turns to purple, and merges its light in the awe-inspiring darkness of the horizon. Deep gloom becomes every moment deeper and more inscrutable along the coast-line, which vanishes into darkness beyond the range of vision. In the middle distance the abbey tower bears the monitory bell, and is reared above a promontory overlooking the sea, upon the waves of which the warning travels 'slow with sullen roar.' The body of the church is lost in the twilight of the landscape, but reflections of the moon tremble on the wavelets that fill the middle of the design with a mirror-like surface of varying gloom, and the wan gold of the sunsetting pervades the scene. Above the moon a lonely star is radiant: below, a bat flitters heavily from its home among the roofs. The trees are still and silent. The inspired herdsman of the poem lingers on his way, and watches

1. Rijksmuseum, Amsterdam

the cattle at the bank where the stream, sparkling sometimes, runs darkling to the beach.

Contrasting in its movements, lustre, and turbulence with the solemnity and still gorgeousness of *The Curfew*, is *Morning*,[1] an illustration of the appearance of 'civil-suited morning'

> Not trick't and frounc't as she was wont
> With the Attic boy to hunt,
> But kerchief'd in a comely cloud,
> While rocking winds are piping loud,
> Or usher'd with a shower still,
> When the gust hath blown his fill,
> Ending on the rustling leaves
> With minute drops from off the eaves.

Here, after a deluging shower, orange light strikes the world, and gleams on cottage-gables, foliage, lofty uplands, and hills. On the distance stupendous vapours cast portentous shadows; the tumult of their movements is indescribable in words, but has been depicted with amazing force and truth. Rolling off in huge disorder, the bulks of thunder-cloud overrun and threaten the hills. Nevertheless, victorious light searches the caverns of the clouds, whitens their summits, and traverses the valleys of the land. Rose,

1. Private collection

red, pure white, and orange, glow on the right and left of this magnificent drawing, in which the painter's finest art has been employed to give the impression of terrors which are not permanent, and are rather startling than awe-inspiring.

A Tower'd City[1] was painted in 1880, and illustrates *L'Allegro*, the sister poem to *Il Penseroso*. It is the fellow picture to *The Curfew*. Here a palace-fortress is topped by battlements, belfries, and coronets of stone, and built along the edge of a lofty river-cliff. Below the last a stream goes swiftly, and being a true mirror is half dark, half light, enriched with reflections of a bridge leading to the city: it bears also the gloom of the cliff-shadows and the white light of the half moon. Purple of sunset, orange light, and flaming gold, charge the sky upwards to the 'still-serene' blue zenith. On our right the road is occupied by a bridal procession, which, 'with plumes and lights,' goes onwards to the city of towers. Over the bridge pass warriors clad in steel, which, like the river below their path, gleams in the twilight of the sun and moon. Technically speaking, and apart from the wonders of this drawing's poetic inspiration, there is the working of a charm in the execution of the rocky

1. Rijksmuseum, Amsterdam

pass, the crowded foliage, the dark buildings and their wealth of reflections. But the most potent wizardry has been employed in this work, as in others, in depicting the aërial perspective of the sky, its 'ply on ply' of sullen-burning clouds and fiery air.

The Lonely Tower[1], which was produced in 1868, may well supply a subject to another of these tributes of admiration. It comprises the designs of one of Palmer's latest plates — a work published by the Etching Club — choice proofs of which enrich these walls. It represents that 'high, lonely tower,' in the topmost chamber of which Milton longed to 'outwatch the Bear,' and call up the spirit of Plato. Here the half moon rides low, and has not yet risen higher than the level of a headland which overlooks the weald, and on whose far-off ridge Druidic stones appear as skeletons, mysteriously solid and dark. On the nearer promontory of this ridge the 'lonely tower,' a keep, of no great size, has been reared. From its window the beams of the lamp of the 'midnight hour,' whose little ray pierces the black shadow of the

1. Yale Center for British Art, New Haven. A later version is in the Huntington Library and Art Collections, San Marino, ill. overleaf. The etching is ill. p. 19

Overleaf: The Lonely Tower, before 1881

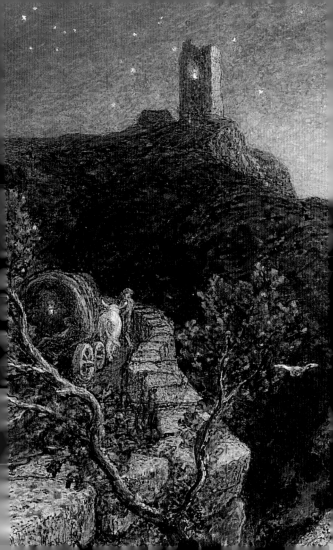

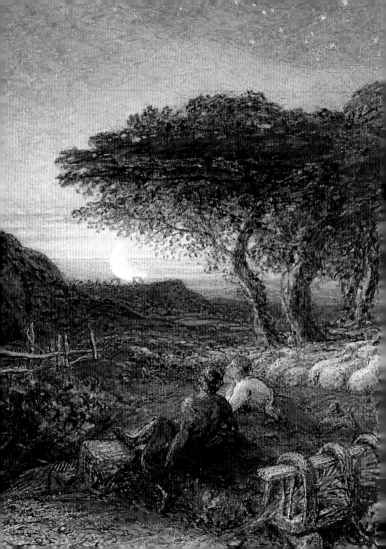

keep's side, rival the lustre of the late-rising moon. A stream flows rapidly at the cliff foot, its cascade-like surface enriched with lights, shadows, and mysterious reflections of the sky, stars, moonlight, and trees. On our right an oak's gigantic boughs seem groping in the twilight; at its base two figures sit and watch the lamplight of the tower; just beyond them the moon reveals the backs of sheep huddled in the fold. Below the moon the horizon is faintly lit by beams of another sort than hers, so that the brevity of her reign is already indicated; short as her pathway is, and low as her arc may be, that reign began long after twilight, and will end with dawn. High in the darkness of the firmament the Bear wheels

Thro' a great arc his seven slow suns.

Wonderfully elaborate as is the etching of *The Lonely Tower*, its subtlety and the wealth of its materials of form and tone are surpassed by the abundance and delicacy of their prototypes in the picture. Such is the fact in all those instances where the etching has followed the painting of a design by Palmer. If such is the case, how much may the student learn about Palmer's genius who, hitherto familiar with his etchings, now for the first time contemplates these pictures at leisure! In this inevitable shortcoming of

reproduction we may find an answer to the question, why our artist lingered so long over and expended so much precious labour on the etchings with which he charmed the world. He was striving to reproduce on the plate as much as possible of what the larger scale of the drawings, and the mode of their execution, admitted on the paper.

The Waters Murmuring,[1] a work of 1877, supplies a theme for the last of these notes. Its design is nearly identical with that of a pen-drawing of amazing spirit, elaboration, and poetry, which Palmer had executed long before the practice of art had enabled him to express his will with technical good fortune. It illustrates *Il Penseroso*, and depicts the nymph moving in the woodland path of a deep valley, and with clashing cymbals hailing the sun, whose light fades from the heights above the scene, and has left vast trees in the shadow. In the centre an oak thrusts forth its monstrous arms, at its foot two lovers ensconced near a hollow sit whispering. A cascade, with blue reflections of the sky upon its waters, falls in the clear shadows of the cliff.

1. ING Bank, London branch

Overleaf: The Waters Murmuring, 1877

List of illustrations

p. 36 The Magic Apple Tree, *c.* 1830, pen and Indian ink, watercolour, in places
mixed with a gum-like medium, on paper, 34.9 x 27.3 cm,
Fitzwilliam Museum, Cambridge

p. 40 Twilight, *c.* 1834, oil and tempera on panel, 23 x 28 cm,
Richard L. Feigen, New York

pp. 44-45 The Shearers, *c.* 1833-34, oil and tempera on wood, 51.4 x 71.7 cm,
courtesy Richard Nathanson, London.

pp. 48-49: Sir Guyon with the Palmer attending, tempted by Phædria to Land
upon the Enchanted Islands, 1849, watercolour and bodycolour with gum
arabic over black chalk on paper mounted on board, 53.7 x 75.1 cm,
The J. Paul Getty Museum, Los Angeles

p. 52 The Eastern Gate, 1881, gouache on paper, 50 x 70 cm, private collection

pp. 58-59 The Bright Cloud, *c.* 1833-34, oil and tempera on mahogany panel,
23 x 32 cm, Manchester City Art Gallery

p. 62 The Skylark (also called The Rising of the Skylark) *c.* 1833 and later,
oil on panel, 30.8 x 24.5 cm, National Museum and Gallery of Wales, Cardiff

p. 65 The Skylark (etching), 1850, etching on chine appliqué, 9.9 x 7.4 cm,
British Museum, London

pp. 68-69 A Kentish Hop-Garden (also called Scene at Underriver, Kent),
c. 1833-34, oil and tempera on panel, 18 x 25.6 cm
Shizuoka Prefectural Museum of Art, Shizuoka

pp. 72-73 A Farmyard near Prince's Risborough, Bucks., *c.* 1845-46, watercolour
with pencil on paper, 39.2 x 54 cm, Victoria & Albert Museum, London

pp. 74-75 A Golden City, *c.* 1873, watercolour and gouache with traces
of pencil, chalk and gum arabic on paper, 51.4 x 71 cm,
National Gallery of Victoria, Melbourne

pp. 82-83 The Comet of 1858, 1858-59, watercolour and gouache on paper,
31.3 x 69.9 cm, private collection, England

pp. 88-89 The Lonely Tower, before 1881, watercolour, gouache and gum arabic on
board, 51.4 x 70.8 cm, Huntington Art Collection, San Marino

pp. 92-93 The Waters Murmuring, 1877, watercolour on paper, 51 x 70 cm,
ING Bank, London Branch

Image credits:
All images courtesy of holding institutions or collectors,
except p. 62, courtesy of Bridgeman Art Library

© 2005, 2020 Pallas Athene (Publishers) Ltd.

Published in the United States of America in 2020 by the J. Paul Getty Museum, Los Angeles
Getty Publications
1200 Getty Center Drive, Suite 500
Los Angeles, California 90049-1682
getty.edu/publications

Distributed in the United States and Canada by the University of Chicago Press

Printed in China

ISBN 978-1-60606-643-0

Library of Congress Control Number: 2019947885

Published in the United Kingdom by Pallas Athene (Publishers) Ltd.
Studio 11A, Archway Studios
25–27 Bickerton Road, London N19 5JT

Alexander Fyjis-Walker, *Series Editor*
Patrick Davies, *Editorial Assistant*
Special thanks to Rachel Barth

Front cover: Samuel Palmer, *Self-Portrait* (detail), ca. 1824–25. Black chalk heightened with white on buff paper, 29.1 x 22.9 cm (11 7/16 x 9 in.). Ashmolean Museum, Oxford, Purchased (Hope Collection Fund), 1932, WA1932.211. Photo: © Ashmolean Museum / HIP / Art Resource, NY

Note to the reader: Samuel Palmer's letter of 1871 was written to F. G. Stephens after the critic had asked for biographical information for an article on the artist, which was published in 1872 in the *Portfolio*. Stephens drew on this material for the essay reprinted here, which formed the principal part of the catalogue of Palmer's first one-man show. This was held in 1881, shortly after Palmer's death, but almost certainly reflected his own choice of works. The catalogue also contained a biographical sketch, condensed, probably by Stephens, from the biography that was being prepared by the painter's younger son, A. H. Palmer. The texts are complete, except that catalogue numbers and other references for visitors to the exhibition have been omitted.